ARTIST'S
WORK
BOOK

The Practical Guide to

DRAWING
STILL LIFE

BARRINGTON BARBER

D1312751

ARCTURUS

ARCTURUS

This edition published in 2010 by Arcturus Publishing Limited
26/27 Bickels Yard, 151–153 Bermondsey Street,
London SE1 3HA

Series Editor: Ella Fern

ISBN: 978-1-84837-279-5
AD001174EN

Printed in China

ARTIST'S
WORK
BOOK

The Practical Guide to

DRAWING
STILL LIFE

CONTENTS

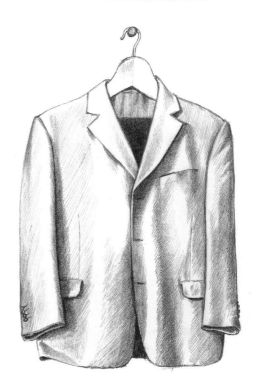

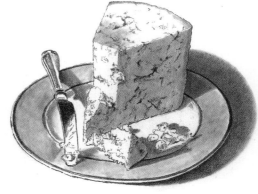

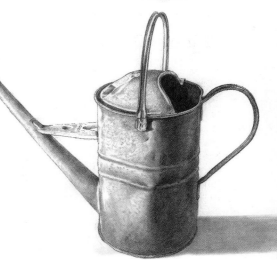

INTRODUCTION

Still life is a very well-practised area of drawing and painting and has been the route by which many artists have learnt about techniques and style. It is the most easily available of art's themes and doesn't require a model or a fine day. The artist has only to look around his home to find all he needs for an enjoyable drawing session.

Perhaps because of its comparatively small scale or domestic nature, it has taken time for still life to be appreciated, and from about 1600 onwards until the 20th century it sat firmly at the bottom of the ladder in the hierarchy of artistic themes. Then still life, or *nature morte*, as the French call it, began to be recognized as having just as much significance in the art of drawing and painting as portraiture, history painting, figure painting, or landscape.

It began to be seen that a brilliant Chardin still life was as good if not better than any painting by a lesser artist, however elevated the theme.

In one sense it is an easy option: all of it can be produced in the studio and it has none of the problems associated with other types of art. Unlike people, the objects of a still life don't move and they don't need rests. As a subject for novice artists still life is ideal because any objects can be used and you can take all the time you need in order to draw them correctly.

Drawing still life opens your eyes to the possibilities of quite ordinary items becoming part of a piece of art. Around any house there are simple everyday groups of objects that can be used to produce very interesting compositions. If you follow my suggestions you will quickly learn how to choose objects and put them together in ways that exploit their shape, contrasting tones and sizes, and also the materials that they are made of.

I have not assumed that all readers of this book will come to it with a great deal of experience of drawing, and so we start at a very basic level. The exercises set out are intended to ease into the subject someone who has never really drawn before, yet also provide useful refreshers for those of you who are already practised in drawing. Primarily we deal first with drawing objects, building up from simple shapes to complex, before moving on to tackle the drawing of still-life arrangements.

With these too we start very simply and gradually bring in more and more objects to create themes; you will have no shortage of themes to choose from. Conversely, you will also discover that arrangements involving few objects can be as, if not more, effective. Some of the most famous still-life artists have restricted their arrangements quite drastically and still become masters of the genre.

I do hope you enjoy exploring this area of drawing with me, and that by the end of the book you will be looking at the objects around you with a keen awareness of the possibilities they offer you for self-expression.

Barrington Barber

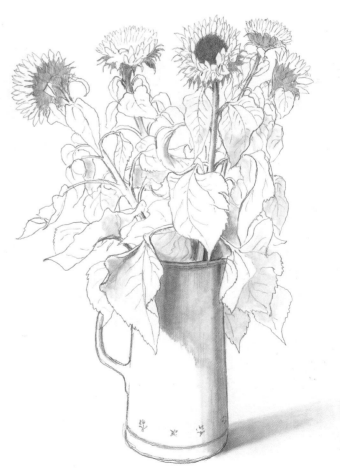

Drawing materials

Any medium is valid for drawing from life. That said, some media are more valid than others in particular circumstances, and in the main their suitability depends on what you are trying to achieve. You don't need to buy all the items listed below, and it is probably wise to experiment: start with the range of pencils suggested, and when you feel you would like to try something different, then do so.

Be aware that each medium has its own identity, and you have to become acquainted with its individual facets before you can get the best out of it or, indeed, discover whether it is the right medium for your purposes. So, don't be too ambitious to begin with, and when you do decide to experiment, persevere.

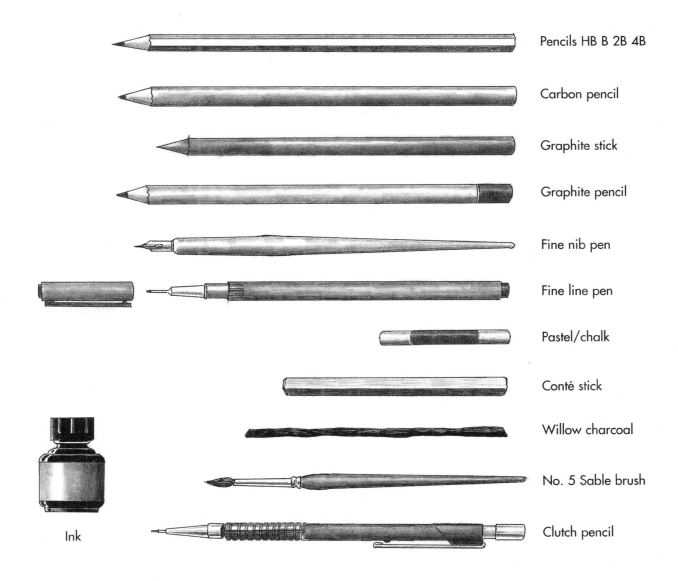

Pencils HB B 2B 4B

Carbon pencil

Graphite stick

Graphite pencil

Fine nib pen

Fine line pen

Pastel/chalk

Conté stick

Willow charcoal

No. 5 Sable brush

Clutch pencil

Ink

TECHNICAL PRACTICES

Every object you draw will have to appear to be three-dimensional if it is to convince the viewer. The next series of practice exercises has been designed to show you how this is done. We begin with cubes and spheres and continue with ellipses on the facing page.

We start with the simplest method of drawing a three-dimensional cube.

This alternative method produces a cube shape that looks as though it is being viewed from one corner.

 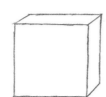 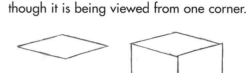 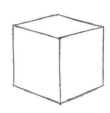

1. Draw a square.

2. Draw lines that are parallel from each of the top corners and the bottom right corner.

3. Join these lines to complete the cube.

1. Draw a diamond shape or parallelogram elongated across the horizontal diagonal.

2. Now draw three vertical lines from the three angles shown; make sure they are parallel.

3. Join these vertical lines.

There is only one way of drawing a sphere. What makes each one individual is how you apply tone. In this example

we are trying to capture the effect of light shining on the sphere from top left.

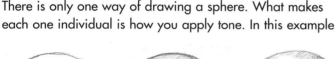
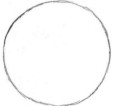 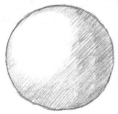 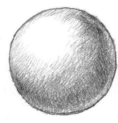 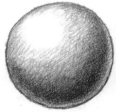 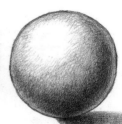

1. Draw a circle as accurately as possible.

2. Shade in a layer of tone around the lower and right-hand side in an almost crescent shape, leaving the rest of the surface untouched.

3. Subtly increase the depth of the tone in much of the area already covered without making it uniform all over.

4. Add a new crescent of darkish tone, slightly away from the lower and right-hand edges; ensure this is not too broad.

5. Increase the depth of tone in the darkest area.

6. Draw in a shadow to extend from the lower edge on the right side.

Ellipses practice: cylinders

Ellipses come into their own when we have to draw cylindrical objects. As with our previous examples of making shapes appear three-dimensional, the addition of tone completes the transformation.

1. Draw an ellipse.

2. Draw two vertical straight lines from the two outer edges of the horizontal axis.

3. Put in half an ellipse to represent the bottom edge of the cylinder. Or, draw a complete ellipse lightly then erase the half that would only be seen if the cylinder were transparent.

4. To give the effect of light shining from the left, shade very lightly down the right half of the cylinder.

5. Add more shading, this time to a smaller vertical strip that fades off towards the centre.

6. Add a shadow to the right, at ground level. Strengthen the line of the lower ellipse.

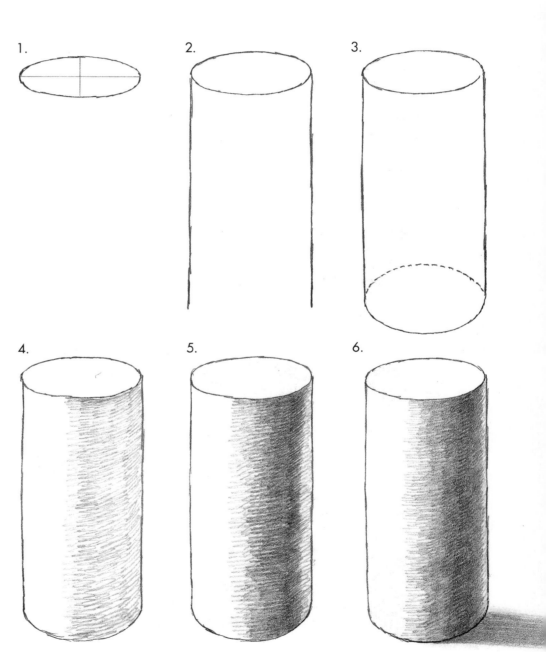

9

SIMPLE OBJECTS

When you are able to complete the practice exercises with confidence, it is time to tackle a few real objects. To begin, I have chosen a couple of simple examples: a tumbler and a bottle. Glass objects are particularly appropriate at this stage because their transparency allows you to get a clear idea of their shape.

In pencil, carefully outline the shape. Draw the ellipses at the top and bottom as accurately as you can. Check them by drawing a ruled line down the centre vertically. Does the left side look like a mirror image of the right? If it doesn't, you need to try again or correct your first attempt. The example has curved sides and so it is very apparent when the curves don't match.

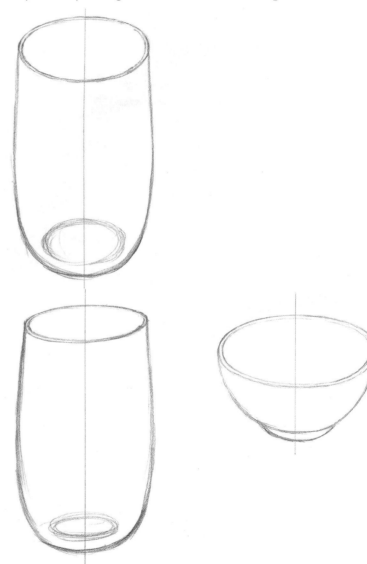

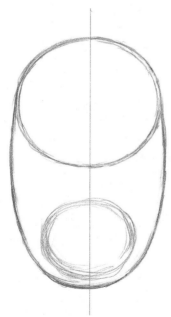

Now shift your position in relation to the glass so that you are looking at it from higher up. Draw the ellipses at top and bottom, then check them by drawing a line down the centre. You'll notice this time that the ellipses are almost circular. Shift your position once more, this time so that your eye-level is lower. Seen from this angle the ellipses will be shallower. Draw them and then check your accuracy by drawing a line down the centre. If the left and right sides of your ellipses are mirror images, your drawing is correct.

You have to use the same discipline when drawing other circular-based objects, such as bottles and bowls. Here we have two different types of bottle: a wine bottle and a beer bottle. With these, start considering the proportions in the height and width of the objects. An awareness of relative proportions within the shape of an object is very important.

 After outlining their shapes, measure them carefully, as follows. First, draw a line down the centre of each bottle. Next mark the height of the body of the bottle and the neck, then the width of the body and the width of the neck. Note also the proportional difference between the width and the length of the bottles.

 The more practice at measuring you allow yourself, the more adept you will become at drawing the proportions of objects accurately. In time you will be able to assess proportions by eye, without the need for measuring.

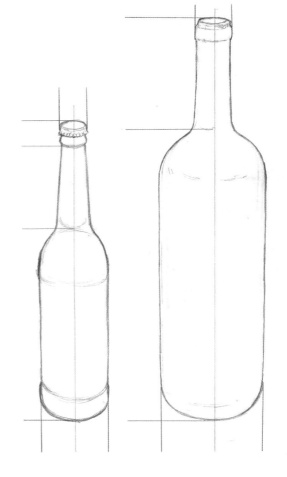

To provide you with a bit more practice, try drawing these objects, all of which are based on a circular shape although with slight variations and differing in depth.

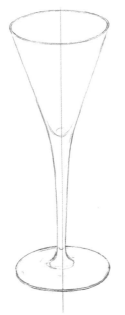
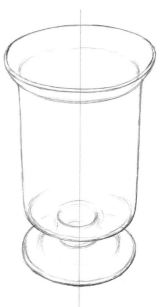

RECTANGULAR PERSPECTIVE

Unlike some other types of drawing, you don't need to know a great deal about perspective to be able to produce competent still lifes. You will, however, find it useful to have a basic grasp of the fundamentals when you come to tackle rectangular objects.

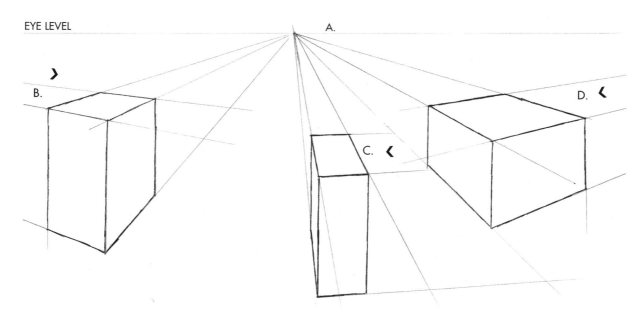

Perspective can be constructed very simply by using a couple of reference points: eye-level (the horizontal line across the background) and (A.) one-point perspective lines (where all the lines converge at the same point).

The perspective lines relating to the other sides of the object (B. C. D.) would converge at a different point on the eye-level. For the sake of simplicity at this stage, they are shown as relatively horizontal.

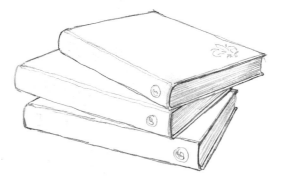

After studying the diagram, try to practise the basic principles of perspective by drawing a range of rectilinear objects. Don't be too ambitious. Begin with small pieces, such as books, cartons and small items of furniture.

You will find that different objects share perspectival similarities – in my selection, compare the footstool with the pile of books, and the chair with the carton.

The wicker basket and plastic toy box offer slightly more complicated rectangles than the blanket box. With these examples, when you have got the perspective right, don't forget to complete your drawing by capturing the effect of the different materials. Part of the fun with drawing box-like shapes comes in working out the relative evenness of the tones needed to help convince the viewer of the solidity of the forms. In these three examples, use tone to differentiate the lightest side from the darkest, and don't forget to draw in the cast shadow.

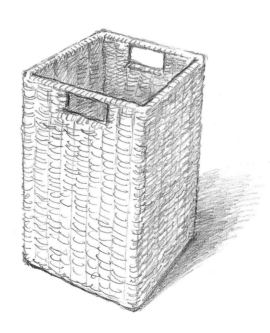

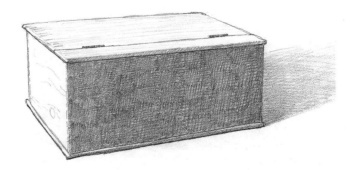

SURFACE TEXTURE

Solid objects present a different challenge and can seem impossibly daunting after you have got used to drawing transparent objects. When I encourage them to put pencil to paper, novice pupils often initially complain, 'But I can't see anything!' Not true. Solid objects have one important characteristic that could have been especially designed to help the artist out: surface texture.

The two darkly glazed objects presented here appear almost black with bright highlights and reflections. Begin by putting in the outlines correctly, then try to put in the tones and reflections on the surface as carefully as you can. You will have to simplify at first to get the right look.

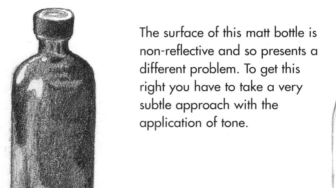

The surface of this matt bottle is non-reflective and so presents a different problem. To get this right you have to take a very subtle approach with the application of tone.

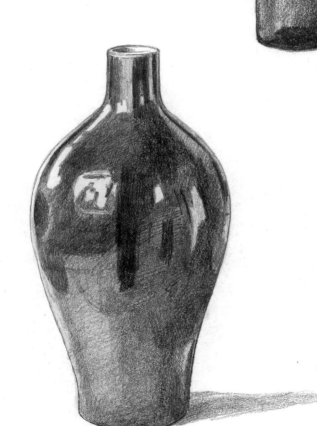

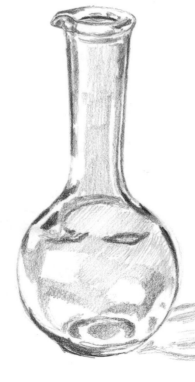

The problem with clear glass is how to make it look like glass. In this example the bright highlights help us in this respect. Other indicators of the object's materiality are the dark tones, which give an effect of the thickness of the glass.

Spherical objects

Spend time on these practices, concentrating on getting the shapes and the various textural characteristics right.

Take the lines of tone vertically round the shape of the apple, curving from top to bottom and radiating around the circumference. Gradually build up the tone in these areas. In all these examples don't forget to draw the cast shadows.

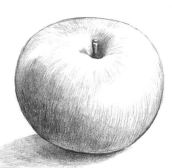

The surface of an egg, smooth but not shiny, presents a real test of expertise in even tonal shading.

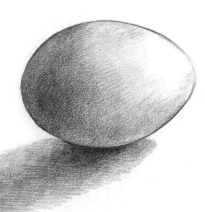

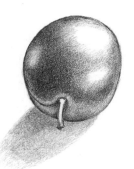

To capture the silky-smooth skin of a plum you need an even application of tone, and obvious highlights to denote the reflective quality of the surface.

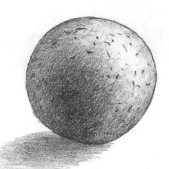

The shading required for this round stone was similar to that used for the egg but with more pronounced pitting.

The orange requires a stippled or dotted effect to imitate the crinkly nature of the peel.

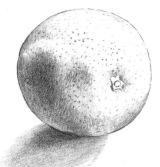

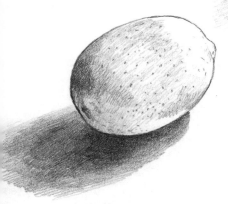

The texture of a lemon is similar to that of the orange. Its shape though is longer.

The texture of this hand-thrown pot is not uniform and so the strongly contrasting dark and bright tones are not immediately recognizable as reflections of the surrounding area. The reflections on the surface have a slightly wobbly look.

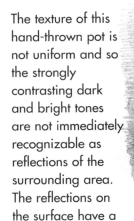

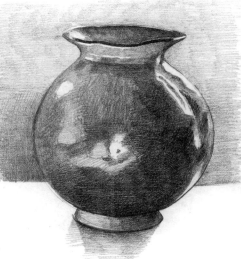

15

DIFFERENT MEDIA

Taking an object and drawing it in different types of media is another very useful practice when you are developing your skills in still life. The materials we use have a direct bearing on the impression we convey through our drawing. They also demand that we vary our technique to accommodate their special characteristics. For the first exercise I have chosen a cup with a normal china glaze but in a dark colour.

With pencil, tonal variations and the exact edges of the shape can be shown quite easily – once you are proficient, that is.

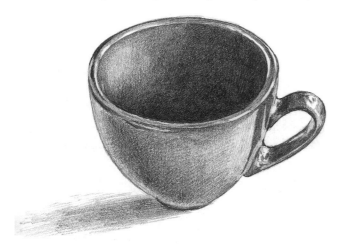

Attempt the same object with chalk (below) and you will find that you cannot capture the precise tonal variations quite so easily as you can with pencil. The coarser tone leaves us with the impression of a cup while showing more obviously the dimension or roundness of the shape. Chalk allows you to show the solidity of an object but not its finer details.

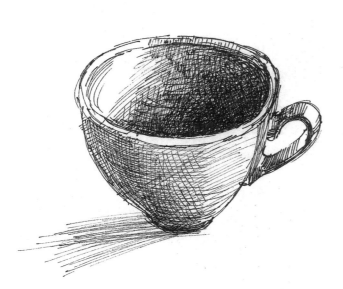

Although ink (left) allows you to be very precise, this is a handicap when you are trying to depict the texture of an object. The best approach is to opt for rather wobbly or imprecise sets of lines to describe both the shape and texture. Ink is more time-consuming than either pencil or chalk but has the potential for giving a more dramatic result.

If you want to make what you are drawing unmistakable to the casual viewer, you will have to ensure that you select the right medium or media. Unfortunately for the beginner, in this respect the best result is sometimes achieved by using the most difficult method. This is certainly the case with our next trio, where wash and brush succeeds in producing the sharp, contrasting tones we associate with glass.

Although this example in chalk is effective in arresting our attention, it gives us just an impression of a glass tumbler.

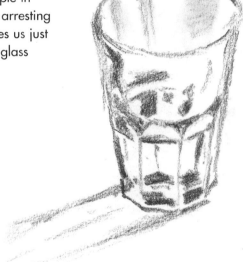

The quality of the material is more strikingly caught with wash and brush, which produces hard, bright surfaces and the illusion of light coming from behind the object.

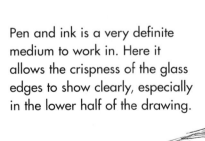

Pen and ink is a very definite medium to work in. Here it allows the crispness of the glass edges to show clearly, especially in the lower half of the drawing.

HANDY HINT

When drawing glass objects it is quite a good idea to simplify the complex shapes of light and dark tones somewhat. This has the effect of increasing the definition and doesn't reduce the verisimilitude.

SHAPES AND PRACTICE

When you have learnt to draw simple shapes effectively, the next step is to try your hand at more complicated shapes. In this next selection, the first set of examples have an extra part or parts jutting out from a main body, in the form of spouts, handles and knobs. Then we look at more subtle changes in shape across a range of objects.

These two items (right) provide some interesting contrasts in terms of shape. Note the delicate pattern around the lip of the sauce-boat which helps to define the plain white surface of the inside. The main point about the jug is the simple spout breaking the curve of the lip.

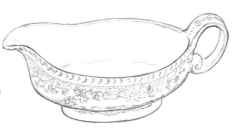

With our next pairing, of teapot and cafetière, the most obvious point of contrast is the texture. The cafetière is very straightforward, requiring only that you capture its cylindrical shape and show its transparency. The teapot is more interesting: a solid spherical shape with a dark shiny surface and reflections. When you practise drawing this type of object ensure that the tones you put in reveal both its surface and underlying structure.

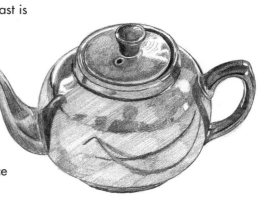

Once you are happy with the accuracy of your outline drawings, you can enjoy the process of carefully putting in the tonal reflections. With any shiny metallic object the contrast between darks and lights will be very marked, so ensure that you capture this effect with your use of tone.

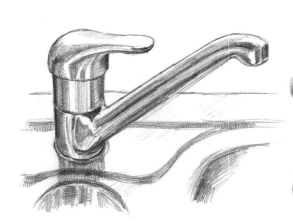

Unusual shapes: wash and brush exercise

Next, to vary the technique of your drawing, switch to a brush and tonal wash, using either ink or watercolour. For this exercise I have chosen a shiny saucepan. As you will have already discovered when carrying out some of the practices on the previous pages, obtaining a realistic impression of a light-reflecting material such as metal can only be achieved if you pay particular and careful attention to the tonal contrasts.

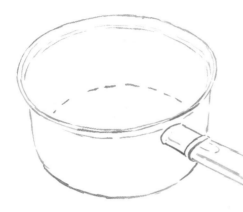

Step 1

Begin by outlining the shape of the saucepan. The critical proportion you have to get right is the relationship between the object's cylindrical body and its long, tubular handle. I chose to place the handle slightly angled towards me to get an effect of it jutting out of the saucepan.

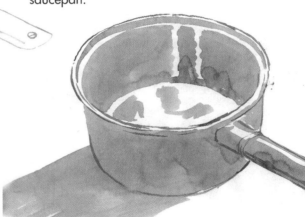

Step 2

When the outline is in place, use a larger brush to put in the main areas of tone; in our example they are in a mid-tone of grey. The highlights were denoted by leaving the paper bare.

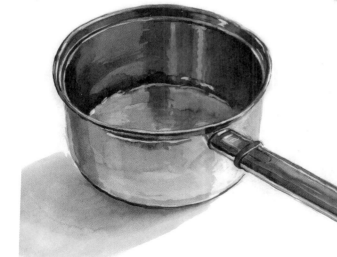

Step 3

For the final stage, take a smaller, pointed brush and work up the detail, applying darker and darker tones. If you inadvertently cover the bright areas, go over them with white gouache to re-establish the highlights.

LARGE OBJECTS

Now we come to objects that cannot normally be considered as still-life objects because of their size. You will have to step out of doors in order to draw them, and encounter the wider world.

There is very little cosmetic design to a bicycle and the interest for the artist is in the unambiguous logic of its construction.

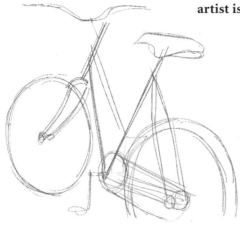

Step 1
Make a quick but careful sketch of the main structure, including the wheels; this is another opportunity for you to look at ellipses (see page 9).

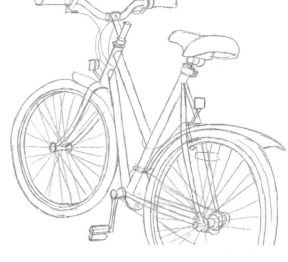

Step 2
Begin to build on this skeleton, producing a clear outline drawing showing the thickness of the metallic tubes and tyres and the shapes of the saddle, handlebars and pedal and chain areas. Observe the patterns of the overlapping spokes on the wheel.

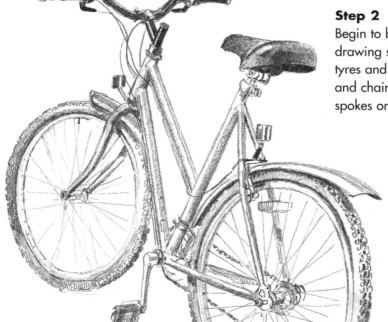

Step 3
Add a bit of toning and some lines to emphasize the shapes.

Here we have two large dynamic objects. The car has a chunky sleek look and a soft line actually enhances the shiny but solid look of the vehicle. The boat has a sharper profile and more elegant line.

Here, the overall light colour contributes to the illusion of sleekness. Tone has been used sparingly; some is needed to indicate the shapes but the reflected light from the water and the white painted hull and super-structure call for brightness and well-defined lines.

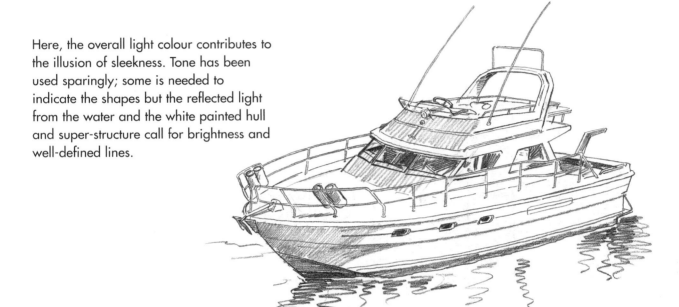

The slightly bulging shape of this rugged vehicle is given even more prominence by the angle. This viewpoint emphasizes the machine's strength and power, without making it look threatening.

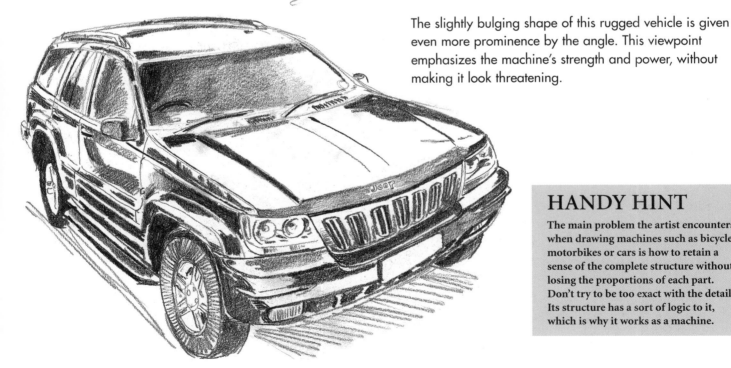

HANDY HINT

The main problem the artist encounters when drawing machines such as bicycles, motorbikes or cars is how to retain a sense of the complete structure without losing the proportions of each part. Don't try to be too exact with the details. Its structure has a sort of logic to it, which is why it works as a machine.

TEXTILES

The best way to understand the qualities of different textures is to look at a range of them. Key with each example is the way the folds of cloth drape and wrinkle. You will need to look carefully too at the way the light and shade fall and reflect across the folds of the material, because these will tell you about the more subtle qualities of the surface texture.

This scarf or pashmina made of the synthetic material viscose is folded over upon itself in a casual but fairly neat package. The material is soft and smooth to the touch, but not silky or shiny; the folds drape gently without any harsh edges, such as you might find in starched cotton or linen. The tonal quality is fairly muted, with not much contrast between the very dark and very light areas; the greatest area of tone is a medium tone, in which there exists only slight variation.

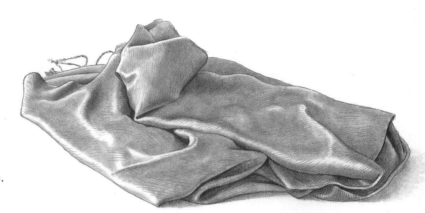

The folds in this large, woolly jumper are soft and large. There are no sharp creases to speak of. Where the previous example was smooth and light, the texture here is coarser and heavier. The showing of the neckline with its ribbed pattern helps to convince the eye of the kind of texture we are looking at.

This well-tailored cotton shirt is cut to create a certain shape. The construction of the fabric produces a series of overlapping folds. The collar and the buttoned fly-front give some structure to the otherwise softly folded material.

A wool jacket, tailored like the shirt on the previous page. Its placement on a hanger gives us a clear view of the object's shape and the behaviour of the material. The few, gentle folds are brought to our attention by the use of tone.

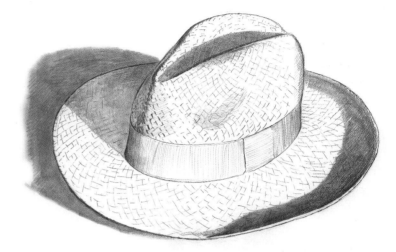

A straw hat produces a clear-cut form with definite shadows that show the shape of the object clearly. The texture of the straw, woven across the structure, is very distinctive. Well-worn hats of this kind tend to disintegrate in a very characteristic way, with broken bits of straw disrupting the smooth line.

This satchel is drawn with quite dark shadows in a few places but is mostly fairly lightly toned to give the effect of a light-reflecting surface, although the material of the bag is black. If I'd felt it to be more true to the object, I could have put a tone of grey over the whole thing to indicate the colour.

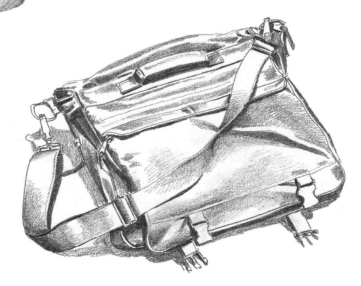

A STILL LIFE IN STEPS

Any ordinary set of objects that you come across in your house can make a good subject for still life. Often you will notice around you things left in arrangements that you would never have put in place as they are found.

This arrangement of a pair of trainers and the socks worn with them might have just been left there by your younger sibling or child. The laces are still loosely tied and the socks draped across one shoe as if just dropped. This sort of arrangement does not need much in the way of background, but if you want to, a few suggestions of the surrounding room could be put in.

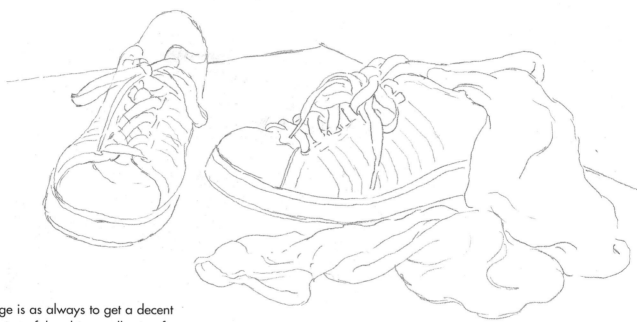

Step 1

The first stage is as always to get a decent outline drawing of the objects, allowing for their positions in relation to each other. This in a way is the most important part of the drawing, because here you can alter and correct until the drawing looks good enough for your standards. When you are satisfied that there is nothing wrong with the drawing, that must mean that it is right. So go ahead.

HANDY HINT

It's important always to draw the simple, overall structure of the group of objects together first. Don't be tempted to draw any one item in detail on its own initially. If you do, you may well find that it is out of proportion with the other items in the group and then you'll need to start all over again!

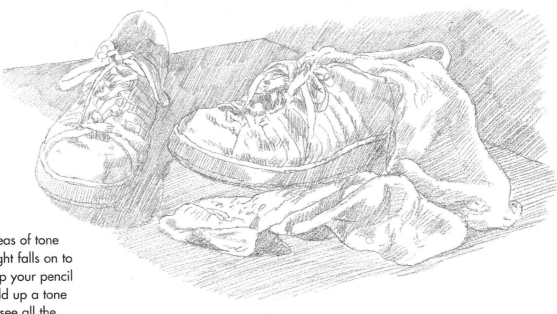

Step 2

Now you need the main areas of tone that describe the way the light falls on to the group. At this stage keep your pencil marks light and even to build up a tone through which you can still see all the relevant lines of construction.

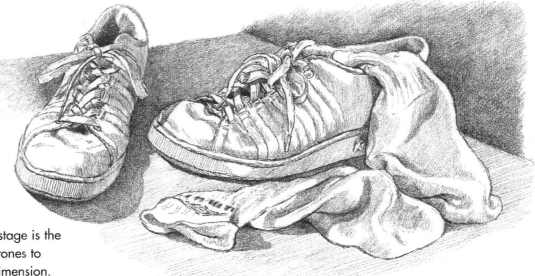

Step 3

Having completed this, the last stage is the gradual build up of the darker tones to help the illusion of depth and dimension. Take a lot of care with this and don't hurry it, and then your results will look more professional. Even the angle of your marks on the paper will change the look of the tonal area, so attention to this detail is rewarded with finer results.

DIFFERENT SUBJECT MATTER

Over the next few pages we will look at some of the wide range of materials you can choose to draw in still-life compositions: paper, wood, glass, metal, bones, shells and stone. Each material, and indeed each object, has its own characteristics and surface texture and you will need plenty of practice to capture these distinct properties.

Paper

In the days when still-life painting was taught in art schools, the tutor would screw up a sheet of paper, throw it on to a table lit by a single source of light, and say, 'Draw that.' In fact, it is not as difficult as it looks. Part of the solution to the problem posed by this exercise is to think about what you are looking at. Although you have to try to follow all the creases and facets, it really doesn't matter if you do not draw the shape precisely or miss out one or two creases.

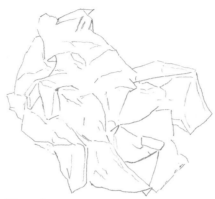

Step 1

Draw the lines or folds in the paper, paying attention to getting the sharp edges of the creases.

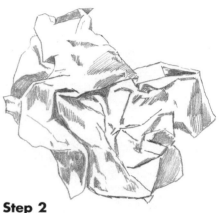

Step 2

Put in the main areas of tone.

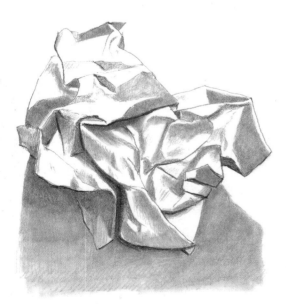

Step 3

Once you have covered each tonal area, put in any deeper shadows, capturing the contrasts between these areas.

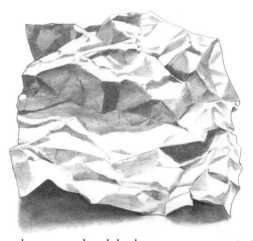

When you have completed the last step, try a variation on it. Crumple a piece of paper and then open it out again. Before you try to draw it, position the paper so that you have light coming from one side; this will define the facets and creases quite clearly and help you.

Follow the three steps of the previous exercise, putting in the darkest shadows last.

Wood

In its many forms, wood can make an attractive material to draw. Here the natural deterioration of a log is contrasted with the man-made construction of a wooden box.

This box presents beautiful lines of growth which endow an otherwise uneventful surface with a very lively look. The knots in the thinly sliced pieces of board give a very clear indication of the material the box is made of.

The action of water and termites over a long period has produced a very varied surface on the sawn-off log; in some places it is crumbling and in others hard and smooth and virtually intact apart from a few cracks.

The grain of the wood has been described in some areas to make this toy look more realistic. It's important not to overdo this effect and let the surface colour take precedence over the form.

HANDY HINT

Look at the object you are drawing with your eyes half closed. You will see more clearly which parts are dark and which are light.

Glass

Glass is a great favourite with still-life artists because at first glance it looks almost impossible to draw. All the beginner needs to remember is to draw what it is that can be seen behind or through the object. The object is to differentiate between the parts that you can see through the object and the reflections that stop you seeing straight through it.

You will find that some areas are very dark and others very bright and often close up against each other.

Make sure that you get the outside shape correct. When you come to put in the reflections, you can always simplify them a bit. This approach is often more effective than over-elaborating.

Draw the outline of this glass as carefully as you can. The delicacy of this kind of object demands increased precision in this respect.

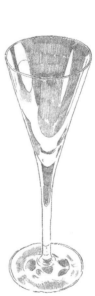

When you are satisfied you have the right shape, put in the main shapes of the tonal areas, in one tone only, leaving the lighter areas clear.

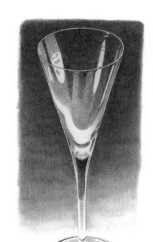

A glass vase, set in front of a white area of background. This allows you to see the shape of the glass very clearly. The tonal areas here will be minimal. If you are not sure whether to put in a very light tone, leave it out until you have completed the drawing, then assess whether putting in the tone would be beneficial.

Finally, put in the darkest tones quite strongly. Each of these three drawings should inform anyone seeing them very precisely about the object and its materiality.

Metal

Now we look at metal objects. Here we have a brass lamp and a silver candlestick, which give some idea of the problems of drawing shiny metallic surfaces. There is a lot of reflection in these particular objects because they are highly polished, so the contrast between dark and light tends to be at the maximum. With less polished metalware such as the watering can below, the contrast won't be so strong.

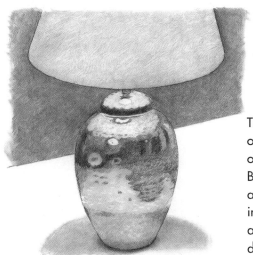

The beaten surface of this brass lamp gives the object many soft-edged facets. Because the light is coming from above, the darkest tones are immediately next to the strong, bright area at the top. The area beyond the darker tones is not as dark because it is reflecting light from the surface the lamp is resting on.

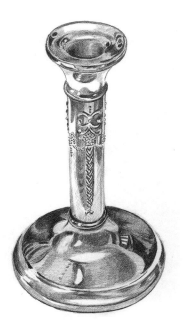

This battered old watering can made of galvanized metal has a hammered texture and many large dents. The large areas of dark and light tone are especially important in giving a sense of the rugged texture of this workaday object. No area should shine too brightly, otherwise the surface will appear too smooth.

A silver candlestick does not have a large area of surface to reflect from. Nevertheless the rich contrast of dark and light tones gives a very clear idea of how metal appears. Silver produces a softer gleam than harder metals. Note how within the darker tones there are many in-between tones and how these help to create the bright, gleaming surface of our example.

HANDY HINT

Take your time with metallic objects. It requires quite a bit of dedication to draw all the tonal shapes correctly, but the result is worth it. Your aim must be for viewers to have no doubt about the object's materiality when you have completed the drawing.

DIFFERENT SUBJECT MATTER

Bones

Skeletons are always interesting to draw because they provide strong clues as to the shape of the animal or human they once supported. They are often used in still-life arrangements to suggest death and the inevitable breaking down of the physical body that is its consequence. Some people may find them rather uncomfortable viewing, but for the artist they offer fabulous opportunities to practise structural drawing.

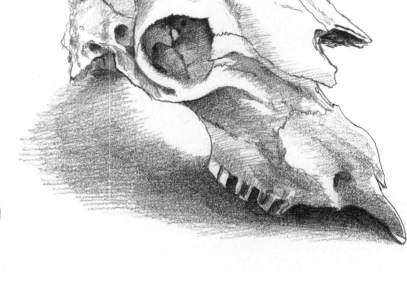

This old sheep's skull found on a hillside in Wales still retains a semblance of the living animal, despite the extensive erosion. The challenge for the artist is to get the dry, hard, slightly polished effect of the old weathered bone.

This is done by keeping the tones mainly light, with only a few very dark tones in the eye-socket or under the teeth. This, and the sharp edges of the tonal areas, help to show its hardness and smooth surface which catches the light.

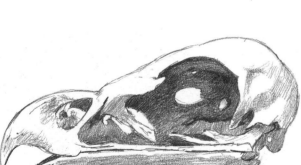

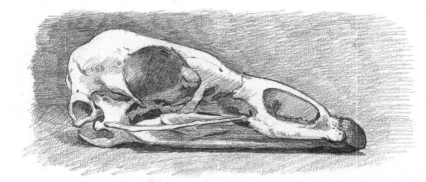

These delicate bony skulls of dead birds are interesting in a similar way to drawing sea shells. Their delicacy and small size makes it necessary that your attention is really on your handling of the drawing. Notice how the inner hollows help to give the bony structure its form.

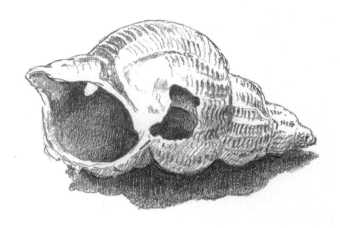

Shells

In contrast to the type of skeleton found in mammals and humans, the exo-skeleton lies outside the body. These shells are all that remain of the molluscs they once shielded. As with the sheep's head, each one reveals the characteristic shape of its living entity. Shells offer the artist practice in the drawing of unusual and often fascinating shapes, as well as different textures ranging from smoothly polished to craggy striations.

Stone

Natural materials such as rock offer a host of opportunities in terms of their materiality. All of the following are hard, solid objects, but that is about as far as the visual similarities go.

Natural forces can shape and form the texture of a very hard substance, as these examples show. Each is at a different stage of weathering, with the chunky piece of rock on the left not yet eroded to the stature of its rounded neighbour, which has been virtually worn smooth by the action of water and other pebbles, save for a small hollow that has escaped this process.

31

FOOD

Food is a subject that has been very popular with still-life artists through the centuries, and has often been used to point up the transience of youth, pleasure and life. Even if you're not inclined to use food as a metaphor, it does offer some very interesting types of materiality that you might like to include in some of your compositions.

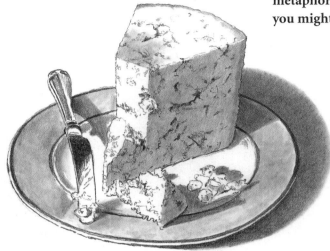

A piece of Stilton cheese, slightly crumbly but still soft enough to cut, is an amazing pattern of veined blue areas through the creamy mass. To draw this convincingly you need to show the edge clearly and not overdo the pattern of the bluish veins. The knife provides a contrast in texture to the cheese.

A freshly baked stick of bread that looks good enough to eat. Where it is broken you can see the hollows formed by pockets of air in the dough. Other distinctive areas of tonal shading are evident on the crusty exterior. Make sure you don't make these too dark and stiff, otherwise the bread will look heavy and lose its appeal.

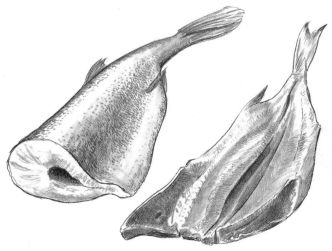

Two views of fish with contrasting textures: scaly outer skin with bright reflections, and glistening interior flesh. Both shapes are characteristic, but it is the textures that convey the feel of the subject to the viewer.

This large cut of meat shows firm, whitish fat and warm-looking lean meat in the centre. Although the contrast between these two areas is almost enough to give the full effect, it is worth putting in the small fissures and lines of sinew that sometimes pattern and divide pieces of meat.

PLANTS

Plants are very accommodating subject matter when you are learning to draw. A great many of them you can bring indoors to observe and draw at your convenience and they offer an enormous variety of shapes, structures and textures. To begin with, choose a flower that is either in your house, perhaps as part of an arrangement, or in the garden. In the exercises below we concentrate on the principal focal point, the head in bloom, although it is instructive to choose a plant with leaves because they give an idea of the whole.

Step 1
Using a well-sharpened pencil, which is essential when drawing plants, outline the main shape of the bloom and the stalk.

Step 2
Draw in the lines of the petals carefully.

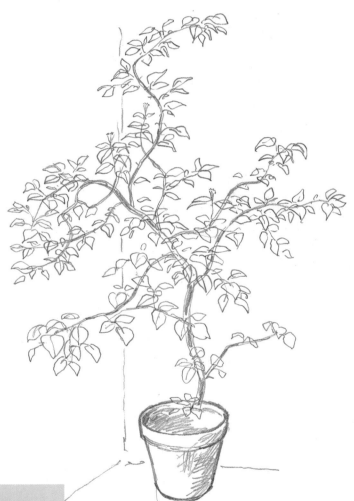

Step 3
Add any tone or lines of texture.

HANDY HINT

Once you start drawing larger plants, you realize that drawing every leaf is very time consuming. It is not necessary to count all the leaves and render them precisely, just put in enough to make your drawing look convincing.

Be very aware of the overall shape and construction of the branches and how the size of the leaves will vary. Look closely at this example and you will understand.

COMBINING OBJECTS

Once you reach this stage in your learning process, the actual drawing of individual objects becomes secondary to the business of arranging their multifarious shapes into interesting groups. Many approaches can be used, but if you are doing this for the first time it is advisable to start with the most simple and obvious.

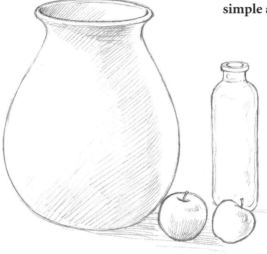

Contrast is the point of these combinations, so when considering the background go for a contrast in tone.

Unusual combinations

Here we look at less usual types of composition where we take something which is not usually considered to be an aesthetically pleasing object, but which, when drawn well and clearly defined, nevertheless produces an interesting result.

With clean laundry of towels, bathmats and tea towels piled neatly on the seat, this ordinary kitchen chair from the last century is as square and simple as is possible. The flat wall as background, and the fact that the whole scene is lit sharply with very little light and shade, produces a strong image.

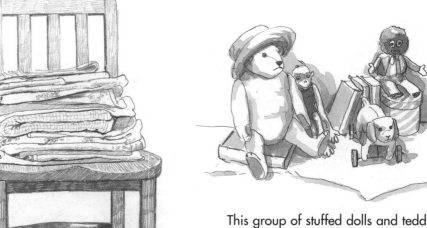

This group of stuffed dolls and teddies with a couple of books seems as though they might be on a nursery shelf.

Encompassed groups

Sometimes the area of the objects you are drawing can be enclosed by the outside edge of a larger object which the others are residing within. Two classic examples are shown here: a large bowl of fruit and a vase of flowers.

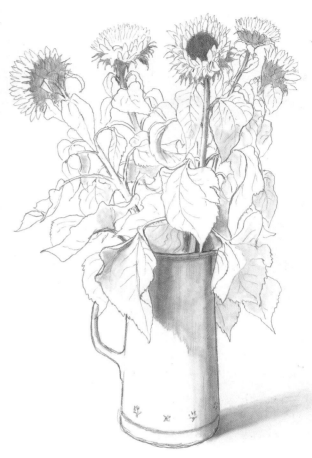

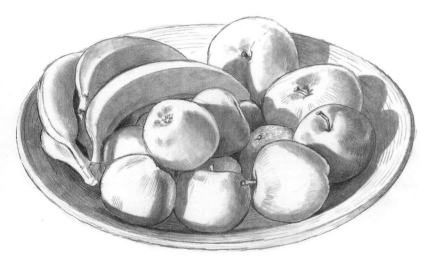

With this type of still life you get a variety of shapes held within the main frame provided by the bowl.

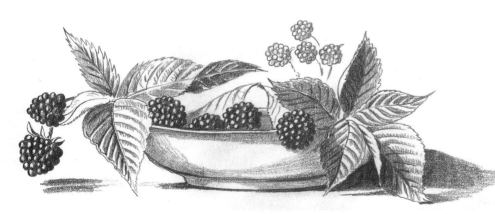

A large vase filled with flowers can be a very satisfying subject to draw. These sunflowers in a large jug make quite a lively picture: the rich heavy heads of the blooms contrast with the raggedy-edged leaves dangling down the stalks, and the simplicity of the jug provides a solid base.

The shiny, dark, knobbly globes of the blackberries and the strong structural veins of the pointed leaves make a nice contrast. The berries are just dark and bright whereas the leaves have some mid-tones that accentuate the ribbed texture and jagged edges.

HANDY HINT

When you come to draw plants, especially flowers, your main task is to avoid making them look either hard or heavy. A very light touch is needed for the outline shapes and it is advisable not to overdo the tonal areas.

MEASURING AND FRAMING

Measuring up

One of your first concerns when you are combining objects for composition will be to note the width, height and depth of your arrangement, since these will define the format and therefore the character of the picture that you draw. The outlines shown below – all of which are after works by masters of still-life composition – provide typical examples of arrangements where different decisions have been made.

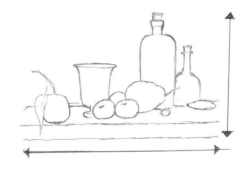

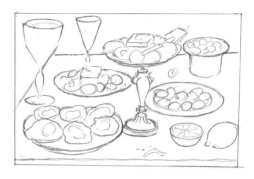

The height is the dominant factor in our first example (after Chardin). The lack of depth gives the design a pronounced vertical thrust.

In our second example (also after Chardin) the width is greater than the height and there is not much depth.

Depth is required to make this kind of arrangement work (after Osias Beert). Our eye is taken into the picture by the effect of the receding table-top and the setting of one plate behind another.

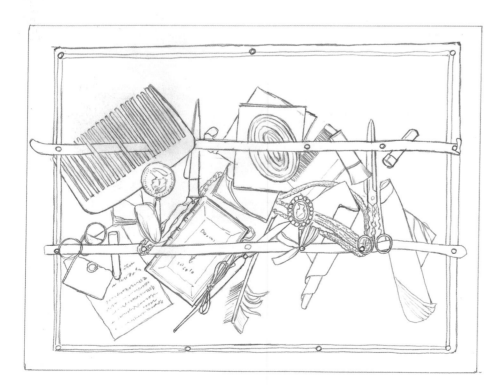

Now for something entirely different, this time after Samuel van Hoogstraten. This sort of still life was a great favourite in the 17th and 18th centuries, when it provided both a showcase for an artist's brilliance and a topic of conversation for the possessor's guests.

Almost all the depth in the picture has been sacrificed to achieve what is known as a 'trompe l'oeil' effect, meaning 'deception of the eye'. The idea was to fix quite flat objects to a pin-board, draw them as precisely as possible and hope to fool people into believing them to be real.

Framing

Every arrangement includes an area that surrounds the group of objects you are drawing. How much is included of what lies beyond the principal elements is up to the individual artist and the effect that he or she is trying to achieve. Here, we consider three different 'framings', where varying amounts of space are allowed around the objects.

1. Here is a large area of space above the main area, with some to the side and also below the level of the table. This treatment seems to put distance between the viewer and the subject matter.

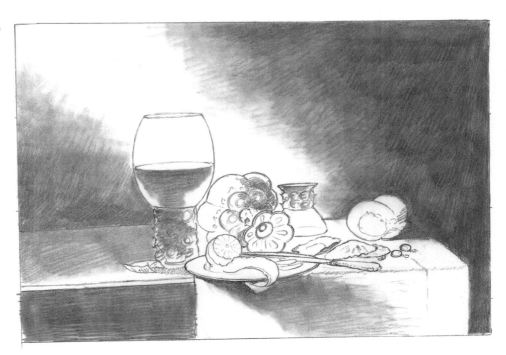

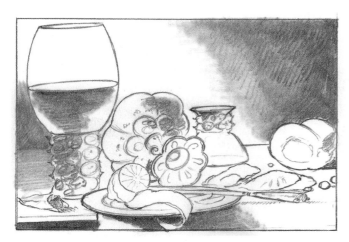

2. This composition is made to look crowded by cropping into the edges of the arrangement.

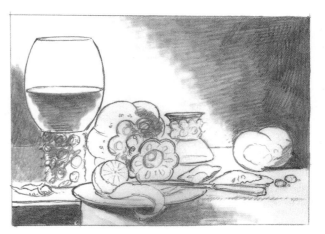

3. This is the framing actually chosen by the artist, Willem Claesz. The space allowed above and to the sides of the arrangement is just enough to give an uncluttered view.

LIGHTING

The quality and nature of the light with which you work will have a large bearing on your finished drawing. A drawing can easily be ruined if you start it in one light and finish it in another. There is no way round this unless you are adept enough to work very quickly or you set up a fixed light source.

Here we show the same three objects arranged in the same way in different lighting versions. Each one also shows the nature of the lighting, in this case an anglepoise lamp with a strong light which shows the direction that the light is coming from.

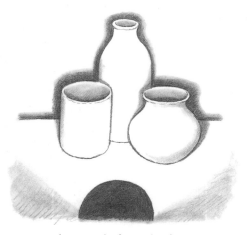

These three pots are lit entirely from the front – the light is coming from in front of the artist. The shadows are behind the pots and the impression is of flatter shapes.

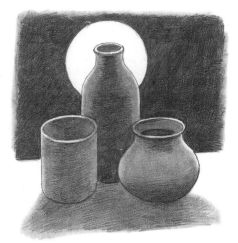

Here the light is right behind the objects. Therefore the pots look dark with slivers of light around the edges. Except for the circle of the lamp the background is dark.

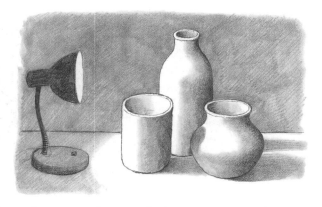

Lighting from one side gives the best impression of the three-dimensional quality of the pots. The cast shadows and the areas of shadow on the pots both help to define their roundness.

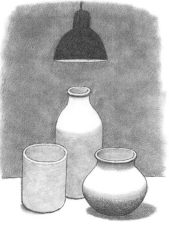

Lighting from above is similar to side lighting but the cast shadows are smaller and the shadow on the pots is, on the whole, less obvious.

The effects of light

Many an art student has been put out by the discovery that the natural light falling on his still-life arrangement has changed while he has been drawing and that what he has ended up with is a mish-mash of effects. You need to be able to control the direction and intensity of the light source you are using until your drawing is finished. If this can't be done with a natural light source, use an artificial lighting set up as demonstrated on the opposite page.

Lit directly from the side; this produces a particular combination of tonal areas, including a clear-cut cast shadow.

Lit from above; the result is cooler and more dramatic than the first example.

HANDY HINT

Directing light from below and to one side is traditionally the way to make objects look a bit odd, unearthly or sinister. Seen in an ordinary light this cherub's expression looks animated, but lit from below, as here, it appears to have a malign tinge.

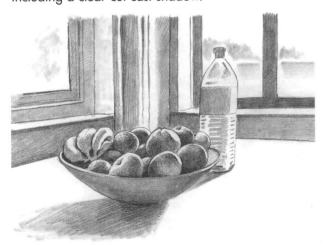

Now for a more traditional form of lighting. The bowl of fruit and the bottle of water are backlit from the large windows with the sun relatively low in the sky; I made this sketch in the evening, but you can get a very similar light in the early morning.

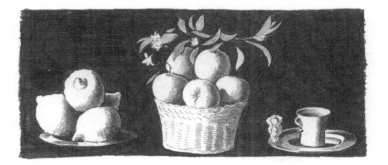

Lit strongly from the side, the strength of the light and the fact that this arrangement is set against such a dark background produces the effect of spotlighting, giving a rather theatrical effect.

MIXING MATERIALS

On these pages we look at the effects of mixing contrasting materials to create lively, varied still-life drawings. The first arrangement shown is one of the tests that has traditionally been set for student artists to help them develop their skill at portraying different kinds of materials in a single drawing. As well as trying this exercise, use your imagination to devise similar challenges for yourself.

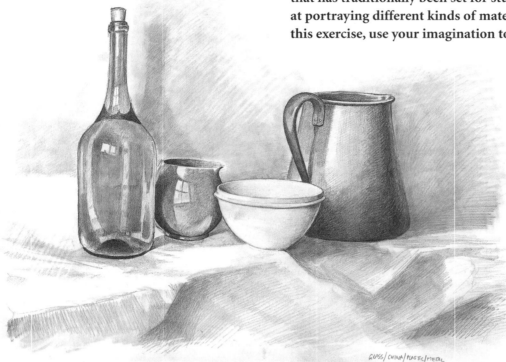

GLASS/CHINA/PLASTIC/METAL

In this still-life group we have a mixture of glass, china, plastic and metal. Note that the glass bottle is filled with water and that the metal jug has an enamelled handle. All the objects are placed on blocks hidden under a soft hessian cloth draped across the background and over the foreground.

HANDY HINT

Experiment with different media to describe a range of textures. For a radical approach you could also try incorporating collage with your drawing.

This is an interesting exercise, though it is a fairly difficult one. Here is an orange sliced in half and a partially peeled lemon, the knife resting on the plate beside them. The real difficulty of this grouping is to get the pulp of the fruit to look texturally different from the peel. The careful drawing of contrasting marks helps to give an effect of the juice-laden flesh of the orange and lemon.

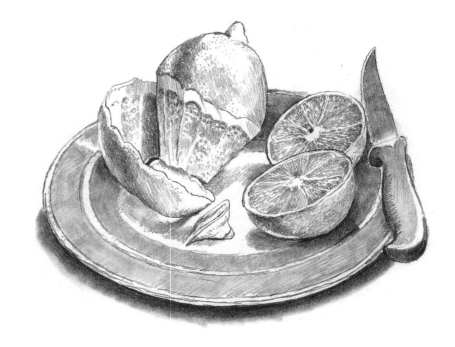

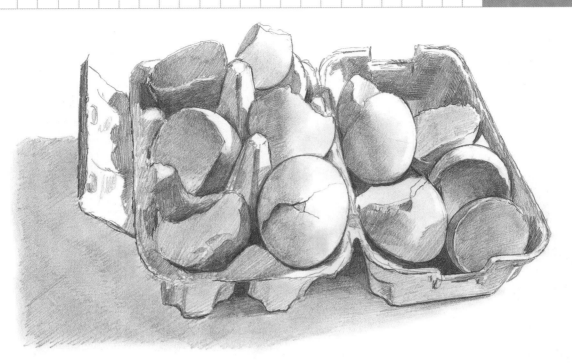

This exercise was quite fortuitous. I came across this egg-box full of broken egg-shells after one of my wife's cooking sessions. She had replaced the broken shells in the box prior to throwing them away. The light on the fragile shells with their cracks and shadowed hollows made a nice contrast against the papier-maché egg-box.

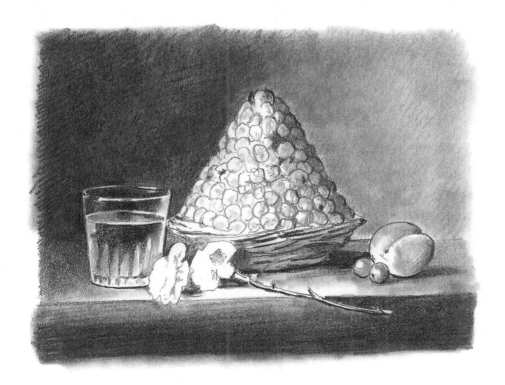

Next we look at a very simple picture by that master of French still life Chardin (see also page 43), who was so renowned in his own lifetime that many collectors bought his works rather than the more complex figure compositions by the artists of the Paris Salon. This picture shows fruit, water and a flower. The heap of strawberries on a basket is unusual as a centre-piece and the glass of water and the flower lend a sensitive purity to the picture.

OTHER ARTISTS

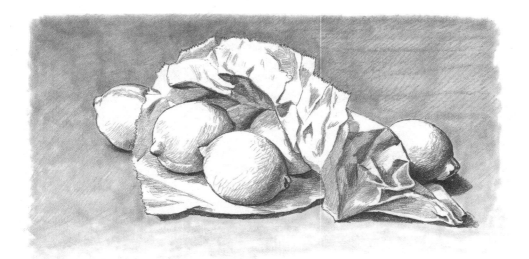

This picture of a few lemons spilled out of a crumpled paper bag has a simplicity and elegance that the British artist **Eliot Hodgkin (1905–87)** has caught well. Again it looks quite a random arrangement but may well have been carefully placed to get the right effect. It is a very satisfying, simple composition.

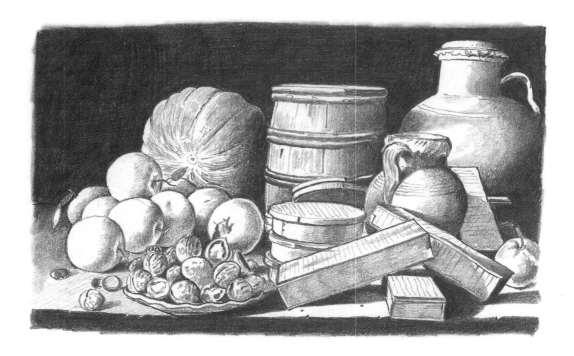

Conversely, this beautiful piece by the famous Spanish artist **Luiz Meléndez (1716–80)** is a full and crowded arrangement. The pots, packets and loose fruits and nuts both contrast and harmonize with each other, making for a solid and balanced-looking group.

The traditional still life at the time of **Jean-Baptiste-Simeon Chardin (1699–1779)** was a complex and very abundant arrangement of flowers, fruits, food of all sorts, and other pots, pans and dishes. Chardin was a new influence on this genre, painting his groups of objects with enormous simplicity and style. His still life had much fewer things in them and used the space around the objects to great advantage. This particular example shows how elegant his composition was. The large spread of the white tablecloth creates a defined setting for the carefully drawn objects, both on the table and on the floor. His use of contrasting shapes and sizes also broke new boundaries in this genre. Sparseness and perfect rendering of forms set new standards for other artists, who quickly copied him.

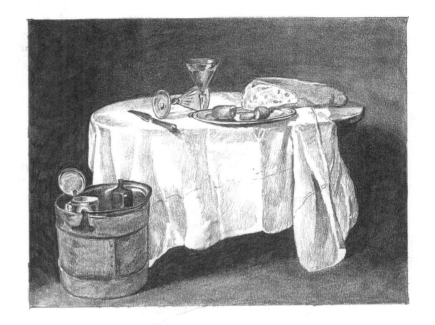

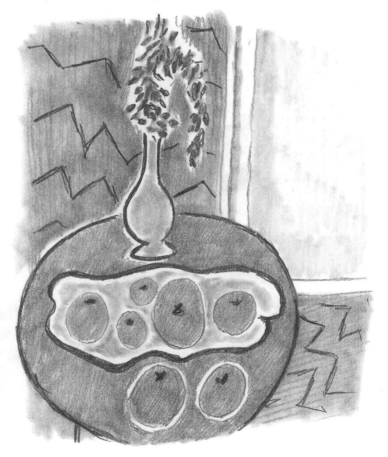

Completely untraditional by comparison is this still life after **Henri Matisse (1869–1954)**. It is arbitrary about the way it uses the shapes of the fruit and flowers. These are important, but not because of their actual substance; Matisse's interest was in the way they create a pattern across the table, which is drawn tilted up towards our gaze. The whole set of shapes creates a very formal pattern, defining the area aesthetically but taking very little notice of the meaning of food or flowers.

THEMES

Another way of using still life is as a kind of narrative, creating arrangements of items which suggest themes, as in the examples shown here. Subject matter such as food (see page 32) can be turned into a theme quite easily, taking the idea of the preparation of a meal. Start with things you know most about, as you will be familiar with the forms of the objects and will invest them with your own emotional response.

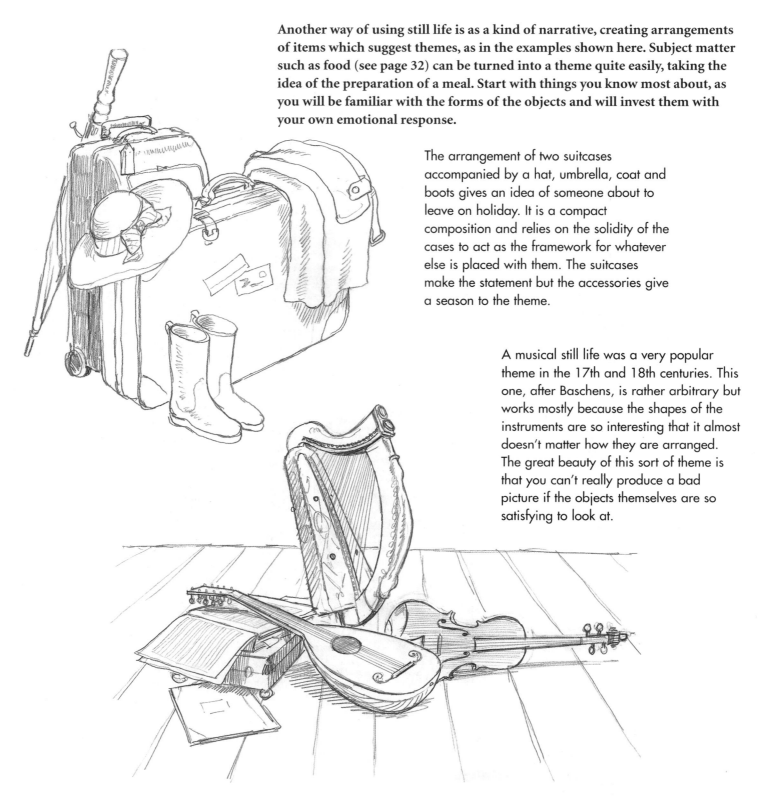

The arrangement of two suitcases accompanied by a hat, umbrella, coat and boots gives an idea of someone about to leave on holiday. It is a compact composition and relies on the solidity of the cases to act as the framework for whatever else is placed with them. The suitcases make the statement but the accessories give a season to the theme.

A musical still life was a very popular theme in the 17th and 18th centuries. This one, after Baschens, is rather arbitrary but works mostly because the shapes of the instruments are so interesting that it almost doesn't matter how they are arranged. The great beauty of this sort of theme is that you can't really produce a bad picture if the objects themselves are so satisfying to look at.

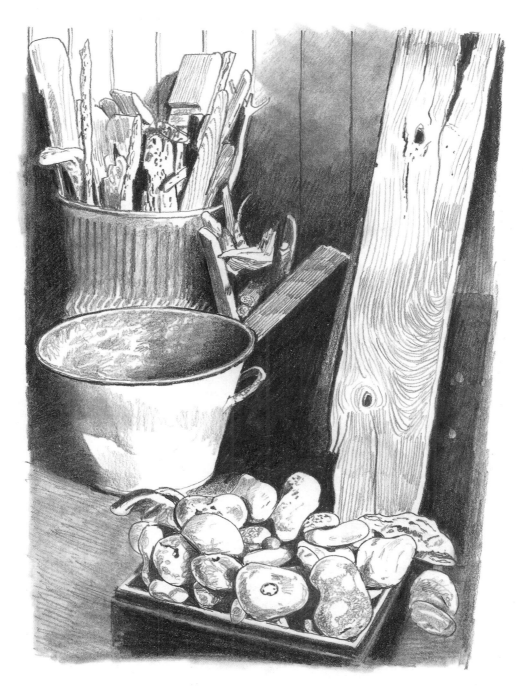

This still life hints at the outdoors, with its piles of driftwood and box of large stones. It gives the impression of a corner of the garden shed, with the collected minerals and wood shoved into battered pails and dustbins. The effect of worn wood and stones brings home the idea of time passing, with the wearing down of natural objects by natural forces. There is a strong suggestion of the sea, even though we can't see it anywhere.

PUTTING IT TOGETHER

On this final spread is a step-by-step guide to developing a more monumental still-life composition. Take the time to set up a similar still life of your own, using all the skills that you have learnt, and follow the steps carefully.

Step 1

I decided on my arrangement and made a fairly quick sketch of it. The first thing I needed to establish was the relative positions and shapes of all the articles in the picture, so I made a very careful line drawing of the whole arrangement, with much correcting and erasing for accuracy. You could use a looser kind of drawing, but this is your key drawing which everything depends on, so take your time to get it right. Each time you correct your mistakes you are learning a valuable lesson about drawing.

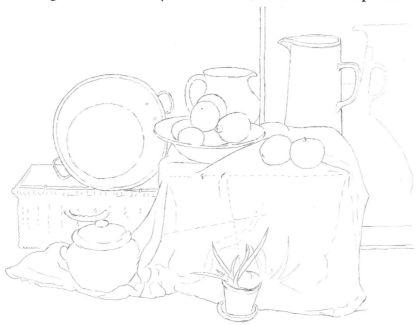

Step 2

After that I blocked in all the areas of the main shadow. Do not differentiate between very dark and lighter tones at this stage; just get everything that is in some sort of shadow covered with a simple, even tone. Once you have done this you will have to use a sheet of paper to rest your hand on to make sure you do not smudge this basic layer of tone. Take care to leave white all areas that reflect the light.

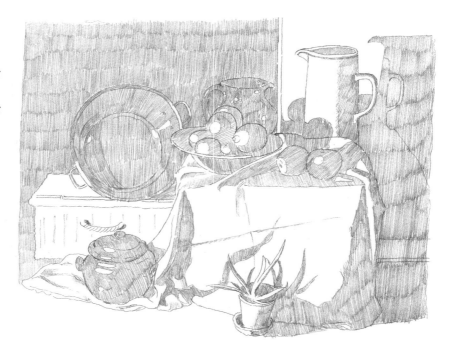

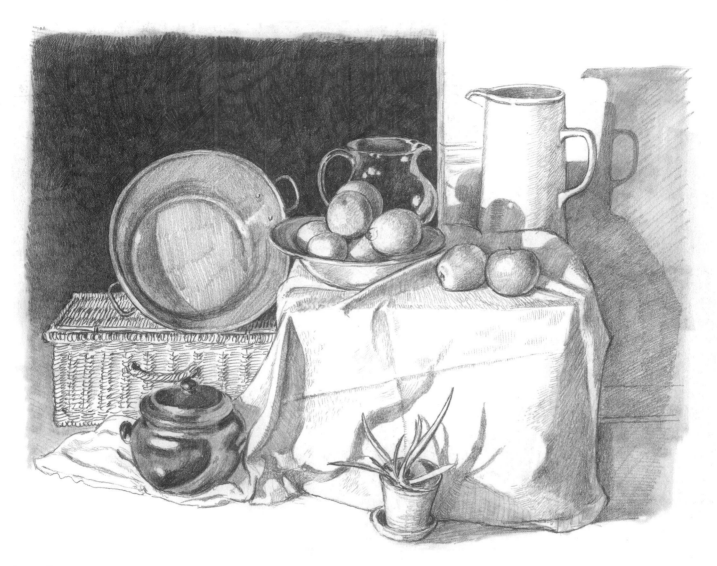

Step 3

Finally, I did the careful working up of all the areas of tone so that they began to show all the gradations of light and shade. I made sure that the dark, spacious background was the darkest area, with the large pan, the glass jug and the fruit looming up in front of it. The shadows cast by the plant and the drapes of the cloth were put in crisply and the shadow of the jug on the wall required some subtle drawing.

Before I considered my drawing finished, I made sure that all the lights and darks in the picture balanced out naturally so that the three-dimensional aspects of the picture were clearly shown. This produced a satisfying, well-structured arrangement of shapes with the highlights bouncing brightly off the surfaces.

INDEX